A CHILD'S BOOK OF ART

DISCOVER GREAT PAINTINGS

Lucy Micklethwait

FIREFLY BOOKS

For Janey and Welly

A DK PUBLISHING BOOK

Published by Firefly Books Ltd. 1999

Senior Editor Jane Baldock
Designer Veneta Altham
Managing Editor Sarah Phillips
Managing Art Editor Peter Bailey
DTP Designers Greg Bryant and Sarah Williams
Jacket Designer Joe Hoyle
Production Josie Alabaster
Picture Researchers Jo Walton and
Katherine Mesquita
US Editors Lilan Patri and Constance Robinson

Copyright © 1999 Dorling Kindersley Limited, London
Text copyright © 1999 Lucy Micklethwait

First printing

Canadian Cataloguing in Publication Data

Micklethwait, Lucy
Discover great paintings

Includes index.
ISBN 1-55209-410-3

1. Art appreciation – Juvenile literature. I. Title.

N7477.M53 1999 701'.1 C99-930297-3

Published in Canada in 1999 by
Firefly Books Ltd.
3680 Victoria Park Avenue
Willowdale, Ontario
M2H 3K1

Picture Credits
The publisher would like to thank the following for their kind
permission to reproduce the photographs:
t = top, c = center, r = right, l = left, a = above, b = below,

Alte Pinakothek, Munich/Artothek: *Portrait of the Marquise de Pompadour* 3br,
16/17, 30cla;
Galleria degli Uffizi/AKG London/Erich Lessing: *Primavera* (Spring) 6/7, 30cra, 31c;
© **David Hockney:** *Self-Portrait with Blue Guitar* 3tl, 28/29, 30clb, 31br;
Kunsthistorisches Museum, Vienna/AKG London/Erich Lessing: *Hunters in the
Snow (Winter)*, 2br, 10/11, 30cb, 31bl;
Musée d'Orsay Paris: *The Bedroom at Arles* 3bl, 24/25, 30bl;
Courtesy, Museum of Fine Arts, Boston: *The Fog Warning* Otis Norcross Fund,
22/23, 30tr;
National Gallery, London: *The Ambassadors* 8/9, 30tc;
National Galleries of Scotland: *An Old Woman Cooking Eggs* 12/13, 30cl;
© **1998 Board of Trustees National Gallery of Art, Washington:** *Saint George and
the Dragon*, Ailsa Mellon Bruce Fund, 4/5, 30tl; *The Dancing Couple*, Widener
Collection 14/15, 30br, *Tropical Forest with Monkeys*, John Hay Whitney Collection,
3cr, 26/27, 30bcr;
©**Tate Gallery, London 1998:** *The Death of Major Peirson* 18/19, 30cr, 31tr; *Christ in
the Carpenter's Shop* 20/21, 30bl.

Jacket:
Alte Pinakothek, Munich/Artothek: *Portrait of the Marquise de Pompadour* Back
Jacket br;
© **David Hockney:** *Self-Portrait with Blue Guitar* (detail), Back Jacket cr;
National Gallery, London: *The Ambassadors* Back Jacket tr;
National Galleries of Scotland: *An Old Woman Cooking Eggs* Back Jacket tc;
© **1998 Board of Trustees National Gallery of Art, Washington:** *Baby at Play* 1876
Thomas Eakins, John Hay Whitney Collection, Front Jacket tl (inset); *Tropical Forest
with Monkeys* John Hay Whitney Collection, Front Jacket, *Saint George and the
Dragon* Ailsa Mellon Bruce Fund, Back Jacket bl; *The Dancing Couple* Widener
Collection, Back Jacket cb.

Color reproduction by GRB, Italy
Printed and bound in Italy by L.E.G.O.

Contents

How to Investigate a Painting

A painting is like an unsolved mystery. And you can be the detective who figures out just what is going on. Look at the evidence and ask yourself questions about it. What are the people wearing? What is the weather like? Is it a noisy scene? Is it sad, happy, or frightening? Look at shapes, colors, and textures. Try to work out the age of the painting and identify unfamiliar objects.

Only the artist has all the answers to all the riddles in a picture, so you can have fun looking for clues and drawing your own conclusions. You may make some interesting discoveries.

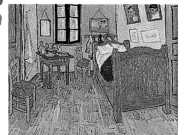

In this book we have made the investigation easier for you. On the left-hand page there are questions. On the right-hand page there are facts about the picture and answers to many of the questions. We added a few details about the artist and indicated the size of the real painting by showing it in relation to an average 5-year-old child.

Once you have mastered the simple art of looking and asking questions, you can apply your investigative skills to any painting in the world.

Saint George and the Dragon

Long ago in a country now forgotten, a wicked dragon lived in a lake near the king's castle. Each day the dragon ate one sheep. When there were no more sheep in the countryside, he started eating the people from the town. Soon he was about to eat the king's daughter. When she saw the dragon, she knelt down and prayed. Just then Saint George appeared. Look at the picture and find out what happened next.

The investigation

What do you think the dragon stands for?

What is the princess doing? Describe what she is wearing.

Find this. What is it?

What can you see reflected in the calm water?

Do you think that the artist used fine paintbrushes or thick paintbrushes?

What is Saint George doing? Describe what he is wearing.

Who do you think lives here?

Who has been eating this?

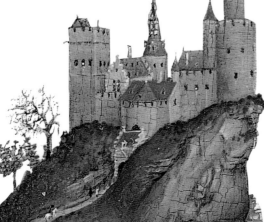

The facts

Look closer

If you look closely you can see two horsemen riding toward the king's castle.

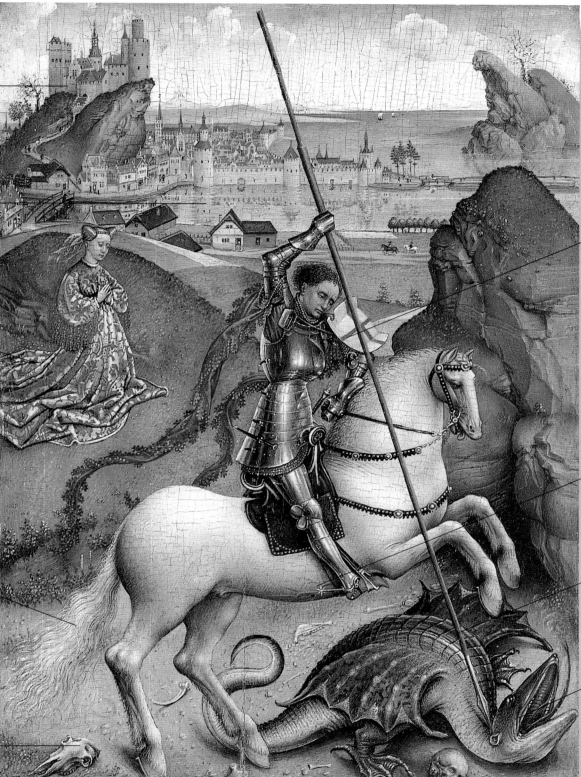

This is the king's castle. He lives here with the princess.

The town is reflected in the water.

The princess is praying to be saved.

These fine lines tell us that the artist used very fine paintbrushes. He probably used a magnifying glass to help him see what he was doing.

This skull, and the human skull below the dragon, show that the dragon has been eating animals and people.

Saint George was made patron saint of England. The red cross on his shield appears on the English flag.

He wears spurs on his feet to make his horse go faster.

He is using a spear to kill the dragon.

The dragon is a symbol that stands for evil.

Behind the scenes

Van der Weyden used oil paint on a small piece of wood about the size of your hand. He painted the picture between about 1432 and 1435, so it is the oldest in the book.

ARTIST **Rogier van der Weyden**

- He was born in around 1400 and died in 1464.
- He had a busy workshop in Brussels with many assistants and pupils.
- His name means Roger of the Meadow.

Primavera (Spring)

The ancient Greeks and Romans believed that there were a great many gods and goddesses who looked after life on earth. Venus was the goddess of love. She was beautiful. Here she is in a garden with some companions. Look closely at the picture and find out who's who in the garden.

Find the blue man with wings.

The investigation

Can you find these hands?

What do you think Mercury is doing with this?

Who is Chloris running away from?

Find this little boy. What is he doing?

Find the goddess Venus. Describe what she is wearing.

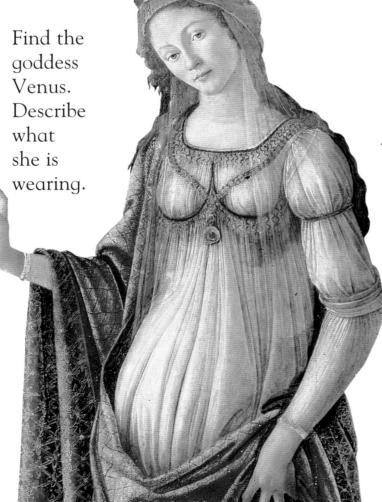

This is Flora. What is she doing?

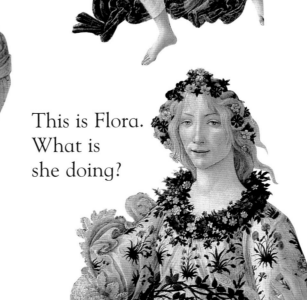

Can you find these feet? What is unusual about the boots?

 # The facts

Look closer

Cupid, the god of love, often stirs up trouble. A person struck by his golden arrow falls in love, but someone hit by his arrow made of lead starts arguing. Here Cupid, who wears a blindfold, aims a golden arrow at one of the Three Graces.

Mercury has a magic stick with snakes on it. He is using it to push the clouds out of the garden.

Venus, the goddess of love

Cupid, the son of Venus

Fruit trees

Zephyr, the west wind of spring

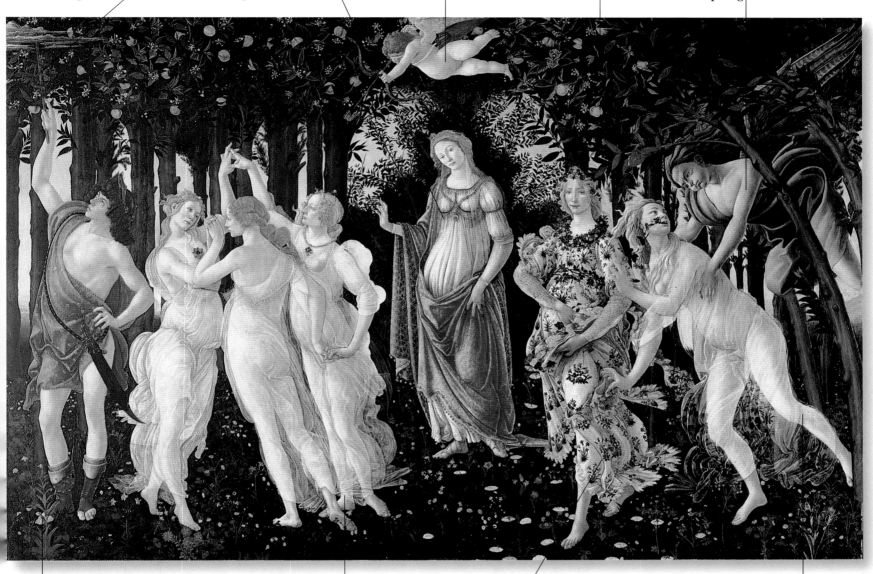

Mercury is the messenger of the gods. The wings on his boots help him fly fast.

The Three Graces are dancing. They are Venus's attendants.

Flora, the goddess of flowers, is scattering flowers on the ground.

This is Chloris. When she married Zephyr, flowers spilled out of her mouth, and she turned into Flora. So Chloris and Flora are the same person.

Behind the scenes

Botticelli used tempera (powdered colors mixed with egg) on a huge panel made of wood. He painted the picture around 1480.

ARTIST Sandro Botticelli

- He was born in Florence around 1445. He died in 1510.
- He painted many pictures for the Medici family, rulers of Florence.
- His real name was Alessandro Di Mariano Filipepi.

The Ambassadors

The French ambassador and his friend are posing for a portrait. They are both important men. The ambassador has been sent to London by the king of France to talk privately with King Henry VIII of England. His friend has come to visit him. The artist has included lots of mysterious objects in the picture. Find out about them and discover more about these two men.

What is this? Can you find one in the picture? To see it properly you must look at it from the side of the page.

The investigation

What do you think this is for?

? Experts are not sure what all the objects stand for. What do *you* think they tell us about the two men and this period in history?

What is the French ambassador holding?

Guess how old this man is.

? The men are wearing expensive clothes. What would the clothes feel like if you touched them?

Find this instrument.

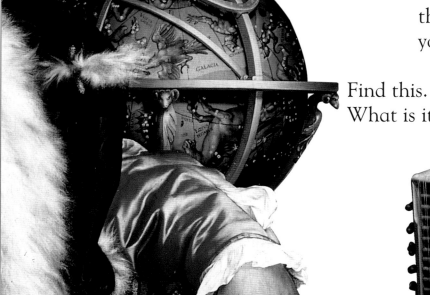

Find this. What is it?

The facts

Jean de Dinteville, the French ambassador

A crucifix showing Jesus Christ on the cross

Both men are wearing fur-lined coats.

The gold dagger case in his hand has his age, 29, written on it.

A globe showing the earth

A celestial globe, which shows the sky and the stars

On the top shelf there are several instruments for measuring time.

A sundial for telling the time

An expensive oriental carpet is displayed on the shelf.

A lute

A hymn-book

A case of flutes

The floor is inlaid with colored marble.

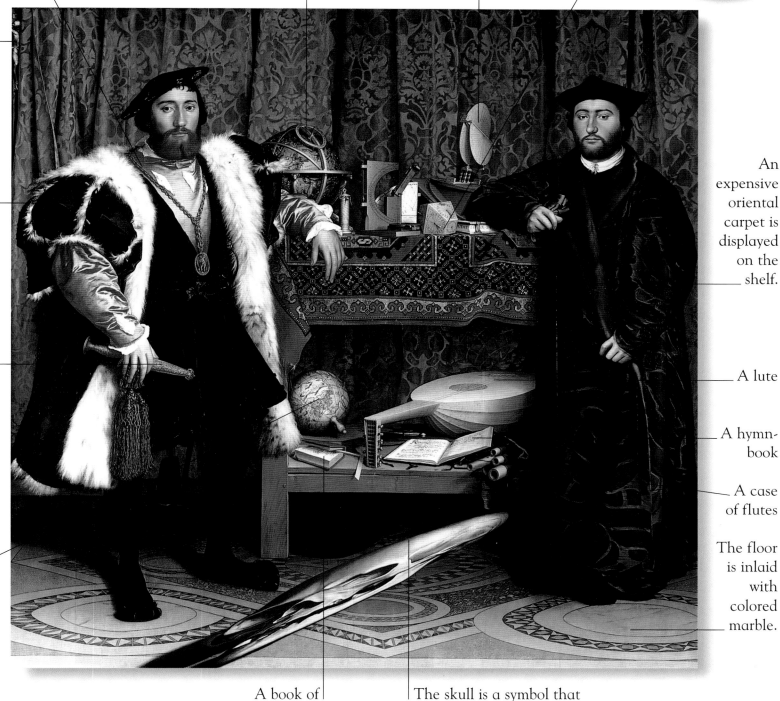

A book of arithmetic

The skull is a symbol that stands for death.

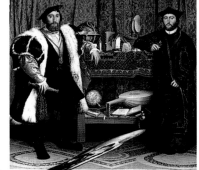

Behind the scenes
Holbein used oil paint on a huge panel made out of planks of oak wood. He painted this portrait in 1533.

ARTIST Hans Holbein the Younger
- He was born in Germany around 1497 and died in 1543.
- He painted many portraits for Henry VIII of England.
- His father, Hans Holbein the Elder, was also a painter.

Hunters in the Snow (Winter)

Fresh snow is lying thick on the ground, and there is more to come. Three men are returning home from a hunting trip with their pack of dogs. Look closely to find out what else is going on in this village scene.

 The investigation

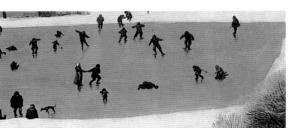

What is the hunter carrying on his back?

Find this church. Why has the artist painted it so much smaller than the buildings at the front of the picture?

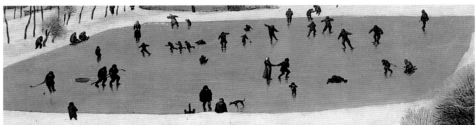

Look closely at the people on the lake. What are they doing?

[?] How do you think these people heat their homes?

Why are the dogs looking so tired?

Find out why the people have l a fire.

Find these girls. What are they doing?

[?] If the artist had painted this scene in the summer, what would it look like and what would the people be doing?

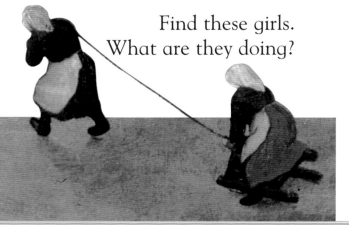

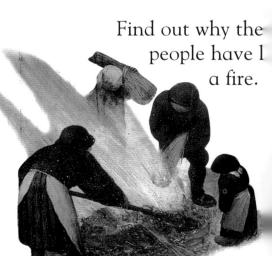

The facts

The inn sign shows Saint Hubert, the patron saint of huntsmen. It is said that Hubert was out hunting one day when he saw a stag with a crucifix (Jesus on the cross) between its antlers.

This straw-fed fire is for singeing the bristly hairs off a pig's carcass before cooking or preserving it.

Each village has a church.

The sky is heavy with snow.

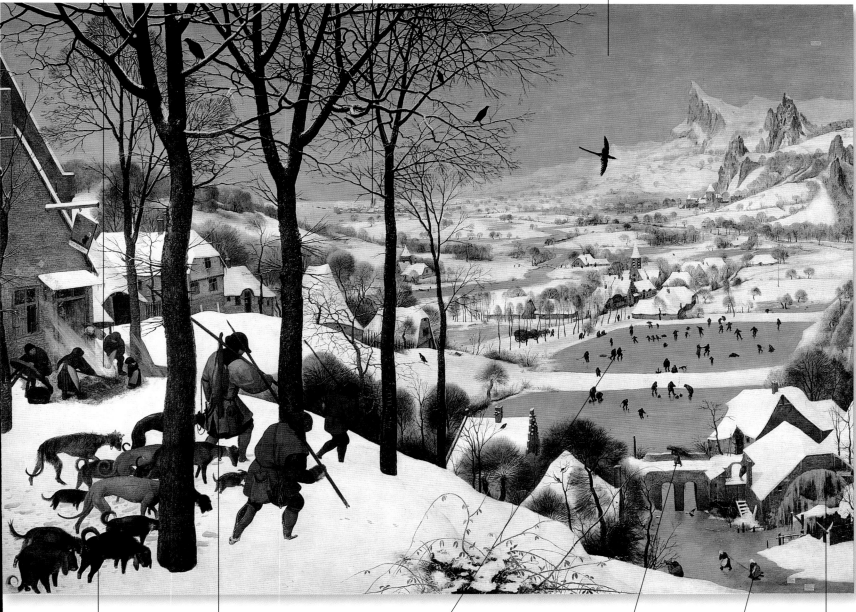

The dogs have been out hunting.

The hunters have caught a fox.

People are skating, sledding, spinning tops, and falling over on the ice.

This woman is carrying a bundle of sticks for making a fire.

One girl is pulling the other on a sled.

A frozen waterwheel

Behind the scenes

This is one of six landscapes that show country life at different times of the year. Bruegel painted it in 1565, using oil paint on a wooden panel.

ARTIST Pieter Bruegel the Elder

- He was probably born between 1525 and 1530, and died in 1569. He lived in Flanders (now part of Belgium).
- His sons Pieter and Jan were also painters.
- His nickname was "Peasant Bruegel."

11

An Old Woman Cooking Eggs

A strange old woman is busy cooking in the kitchen. Who is she cooking for? What is she saying to the boy? Could she be his grandmother? No one knows the answers to these questions, so look closely at the picture and make up your own story.

 investigation

Who does this hand belong to?

What might the boy be thinking?

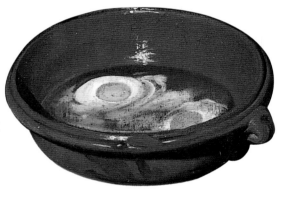

Where is the heat coming from to cook the eggs?

If you could touch this pitcher, how would it feel?

? How many of the objects in the painting do you have at home?

What is this?

? What do you cook on at home?

The boy has a flask in his left hand. What is it made of?

What does the shadow of the knife tell us about the light?

What would the woman use this for?

The facts

The eggs could be in oil or water. To stop the white from spreading when you poach an egg you add vinegar to the water and stir gently around the yolk with a wooden spoon.

This could be a melon or a gourd. A gourd is a fruit that, when hollowed out, can be used to carry liquid.

One side of the boy's face is brightly lit.

A glass flask of wine or vinegar

A basket

The woman seems to be looking at someone outside the painting.

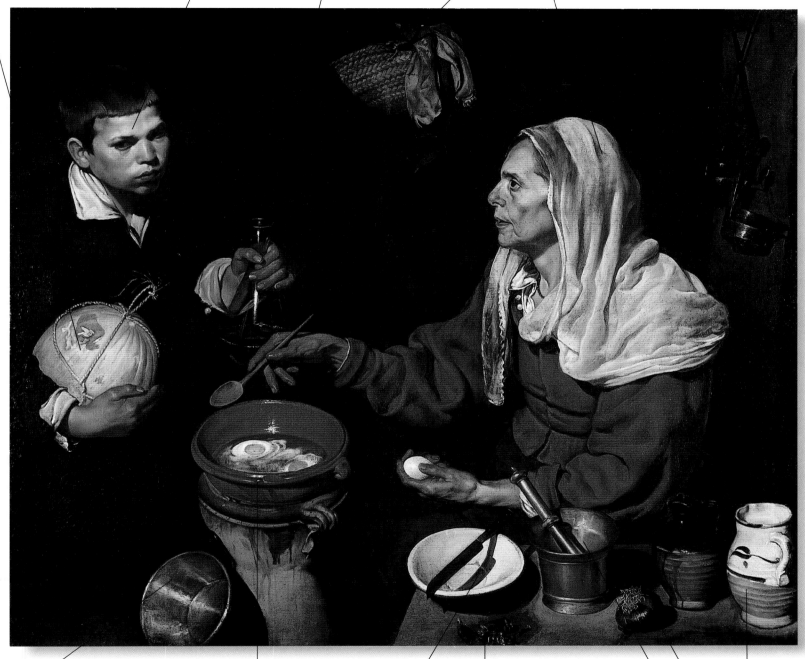

A brass bowl

The eggs are in a terra-cotta bowl on top of a brazier filled with burning charcoal. This heats up the bowl.

The shadow of the knife tells us that strong light is coming from the left.

Chili peppers

A brass mortar (bowl) and pestle (tool) for grinding garlic and herbs

A red onion

The lower part of each pitcher is unglazed.

Behind the scenes

This kitchen scene was painted in 1618 when Velázquez was only 19 years old. He used oil paint on canvas.

ARTIST Diego Velázquez

- He was born in Spain in 1599 and died in 1660.
- Early in his career he painted a series of pictures showing ordinary people at work.
- Later he painted many portraits of the Spanish royal family.

The Dancing Couple

It's party time. Everyone is invited, young and old. Musicians are playing. The guests are eating, drinking, and chatting, and someone has started to dance. Imagine that you are one of the guests at the party: Find out a little about life in Holland three hundred years ago.

The investigation

Find this man. Describe his clothes.

What might this lady be thinking?

? What noises would you be able to hear if you were at this party?

Find out why the stem of this pipe is so long.

This boy is playing a violin. What other musical instrument can you see?

Find this boy. What is he doing?

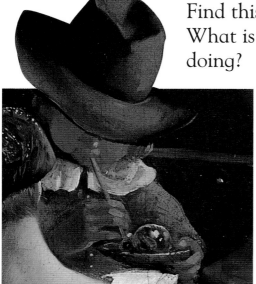

What do you think is in this jug?

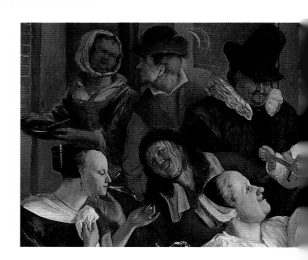

? Find the artist's signature.

The artist is somewhere in the picture. Can you find him?

14

The facts

Look closer

The eggshells, dying flowers, and bubbles are symbols. They tell us that life is short and that good things, like parties, never last long.

The artist

The elderly people are watching the dancing.

A birdcage

By including the church, the artist may be saying that religion is important, too.

A violin A flute

A jug of wine

The artist's signature

Both young boys and girls wore dresses. This child is holding a wooden toy and is wearing a padded hat for protection.

The stem of the pipe is long so that the smoke can cool down before reaching the mouth. The terra-cotta bowl is filled with hot coals for lighting the pipe.

This boy is blowing bubbles.

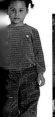

Behind the scenes

Steen put the date of this painting, 1663, beside his signature. He used oil paint on canvas.

ARTIST Jan Steen

- He was born in Holland around 1626 and died in 1679.
- He is famous for his cheerful scenes of everyday life in Holland. Often they contain hidden messages.
- If someone describes your home as a "Jan Steen household" it means that they think it is messy.

Portrait of the Marquise de Pompadour

The title *marquise* tells us that Madame de Pompadour is a noblewoman. A friend and adviser to the king of France for many years, at 35 she has just become lady-in-waiting to the queen. Her portrait is being painted by her favorite artist, François Boucher. Find out more about her.

The investigation

What is Madame de Pompadour holding?

Do you know what sort of dog this is?

What do the roses stand for?

What do you think these objects are used for?

[?] If François Boucher was going to paint a portrait of you, which of your favorite things would you ask him to put in it?

Do you think these look comfortable?

The candle is not lit. Does the room have electric lights?

[?] Madame de Pompadour is interested in all sorts of things. Can you figure out from the painting what they are?

Think of three words to describe Madame de Pompadour's dress

The facts

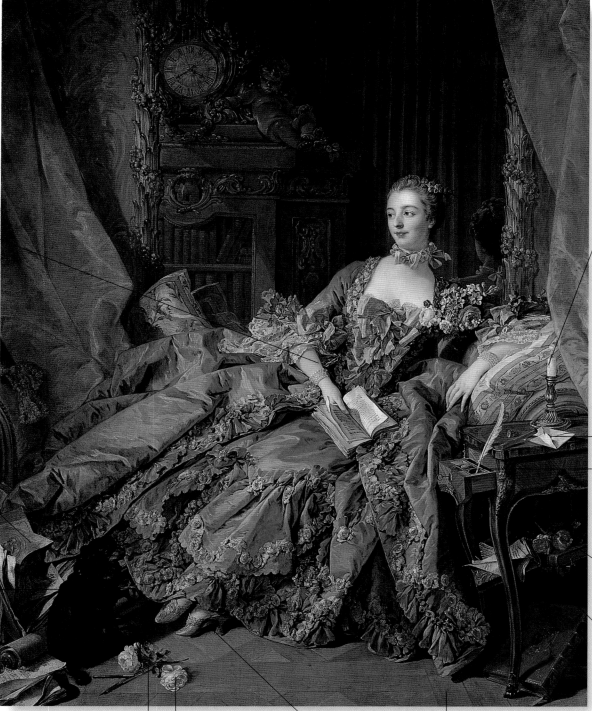

Look closer
The clock is reflected in the mirror, so it appears backward. The time is twenty past eight. What else can you see in the mirror?

Madame de Pompadour is known for her beauty and style (she started the fashion for the low-cut dress herself). She is also intelligent, witty, and powerful.

She is studying drawing and engraving. Her teacher is Boucher.

Her pet dog is a King Charles spaniel called Mimi.

The sheet music is here because she is a talented singer.

The candle would be lit in the evening. There are no electric lights.

When Madame de Pompadour has written a letter she melts a blob of red sealing wax onto the back of an envelope. She stamps it with her gold seal.

A quill pen is balanced in the inkwell.

An elegant writing table

Books

Tools for engraving pictures

The rose is a symbol that stands for love.

Fashionable silk slippers

The grain of the wood runs in different directions to make a pattern on the floor.

Behind the scenes
Boucher painted this portrait in 1756. In 1758, he painted another one that is exactly the same except for the time on the clock. He used oil paint on a large canvas.

ARTIST François Boucher
- This French artist was born in 1703 and died in 1770.
- He was very popular in the court of the French king Louis XV. His style of painting is called Rococo.
- He worked very hard, often for 12 hours a day.

The Death of Major Peirson

It is a cold January morning in 1781. We are in Jersey, an island off the coast of France. Jersey belongs to Britain but the French want it back. The French army has landed in the dead of night, marched to St. Helier (the capital), and forced the governor to surrender. The British soldiers, led by Major Francis Peirson, have launched a counterattack and there is a fierce battle in the town center. Find out what happens.

Who is this?
What is he doing?

The investigation

[?] Imagine you are watching this battle from one of the windows. Describe the noises you would hear.

Which side does this flag belong to?

[?] Do you think this battle really did take place, or did the artist make it up?

What do the soldiers have attached to the ends of their guns?

Who is this? What has happened to him?

Describe the uniform of the British soldiers.

Who is this wounded man

Find the drummer.

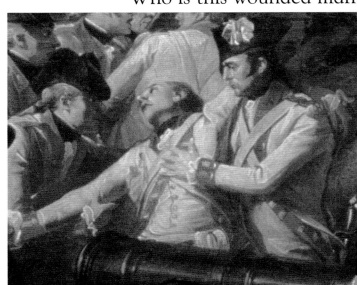

The facts

Look closer

The gold statue is of King George II of England. It still stands in the Royal Square in the center of St. Helier.

There are more British soldiers on the hill.

The soldiers are carrying rifles with bayonets.

The Union Jack is the British flag. The British won the battle.

The French sniper who shot the major is wounded. The French soldiers have rose-shaped cockades (ornaments) on their hats.

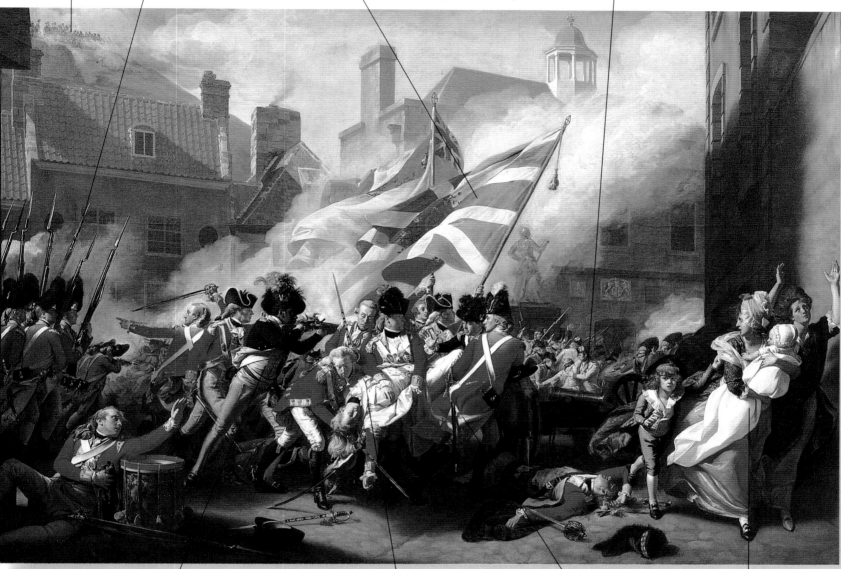

Pompey is Major Peirson's servant. He is shooting at the French sniper who shot his master.

Major Peirson has been shot by a French sniper and he is dying. He is only 23 years old.

The officers are carrying swords.

The women and children are terrified.

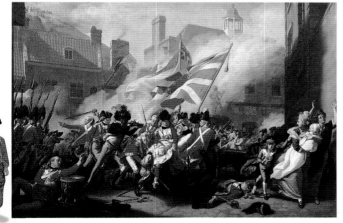

Behind the scenes

Copley was asked to record this scene shortly after the battle took place on January 6, 1781. He finished it in 1783. He used oil paint on a huge canvas.

ARTIST
John Singleton Copley

- This American painter was born in 1738 and died in 1815.
- He taught himself to paint.
- He left his home in Boston in 1774 and settled in London.

Christ in the Carpenter's Shop

The Bible tells us that Jesus Christ was the son of Mary who was married to a carpenter called Joseph. They lived 2000 years ago. Here is Jesus in Joseph's workshop. Find out who is with him and what has just happened.

The investigation

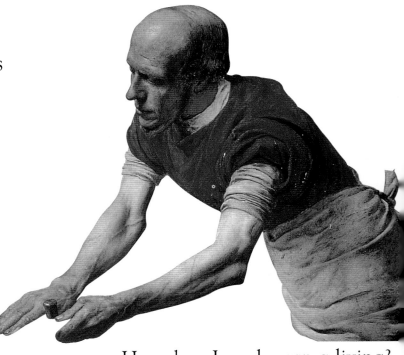

How does Joseph earn a living?

What machinery would you expect to see in a carpenter's shop today?

Who is this?

If Jesus were living now, what do you think he would look like?

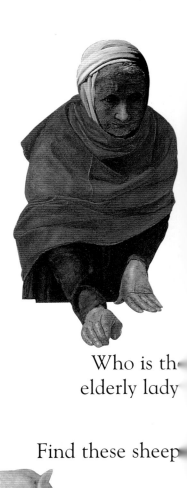

Saint John is Jesus' cousin. What is he doing?

What has Jesus done to his hand?

What is this used for?

Who is the elderly lady?

Find these sheep

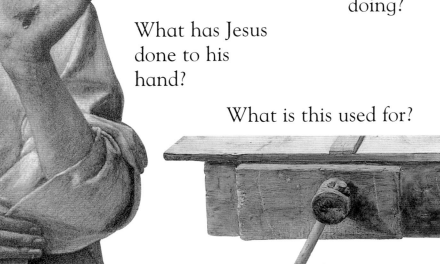

The facts

Look closer
The dove stands for the Holy Spirit, which will be sent from heaven when Jesus is baptized. Today we use the dove as a symbol of peace.

The flock of sheep stands for Jesus' followers.

Pliers for pulling out nails

Saint Anne, the mother of Mary, is Jesus' grandmother.

Tools are hanging on the wall. There is a bow saw for cutting curves in wood.

Joseph is wearing a carpenter's apron.

A bird is drinking from a bowl on the sill.

Timber supply

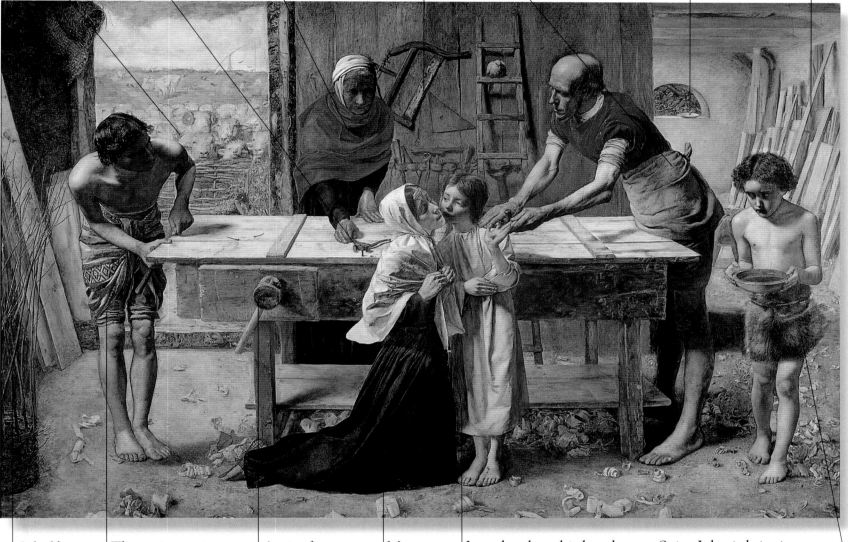

A half-finished basket

The assistant is holding the planks together.

A vise for holding wood is attached to the workbench.

Mary, mother of Jesus

Jesus has hurt his hand on a nail. Blood has dripped onto his foot. The scene reminds us that one day he will be crucified.

Saint John is bringing water to wash Jesus' hand. He is wearing an animal skin. When the boys are grown up, John will baptize Jesus with holy water in the Jordan River.

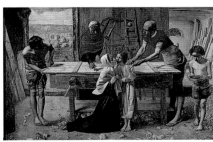

Behind the scenes
Millais painted this scene between 1849 and 1850. His father modeled for Joseph's head but a real carpenter modeled for the arms.

ARTIST John Everett Millais
- An English artist, he was born in 1829 and died in 1896.
- He went to art school when he was only 11 years old.
- He was the first artist ever to be knighted, and he became Sir John Everett Millais.

The Fog Warning

The fisherman is far out at sea. He has been towed to the deep water by a sailing ship and then left to do his work. It is a dangerous way to earn a living but today he has caught at least two fine fish. Suddenly he hears the sound of the ship's horn. He looks up at the sky and realizes he is in great danger. Find out why.

 The investigation

What do you think the fisherman is looking at?

Why is the sea so rough?

[?] What do you think will happen if the fisherman does not reach the ship in time?

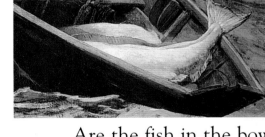

Are the fish in the bow or the stern of the boat

[?] Describe how you would feel if *you* were rowing the boat.

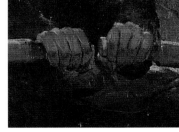

The fisherman is rowing as fast as he can. Why?

There is a strange shap in the sky. What is it

Find out what sort of fish this is. Does it live in salt water or fresh water?

Find this. What is it?

[?] Think of two things you ca smell in the picture

The facts

The bow of the boat is riding high on the crest of a wave. This is a rowboat called a dory.

The anchor is a traditional symbol standing for hope.

A dark bank of fog is spreading across the sky.

The sailing ship on the horizon is sounding a fog warning. The fisherman must reach the ship before he is swallowed up by the dense fog and is lost at sea.

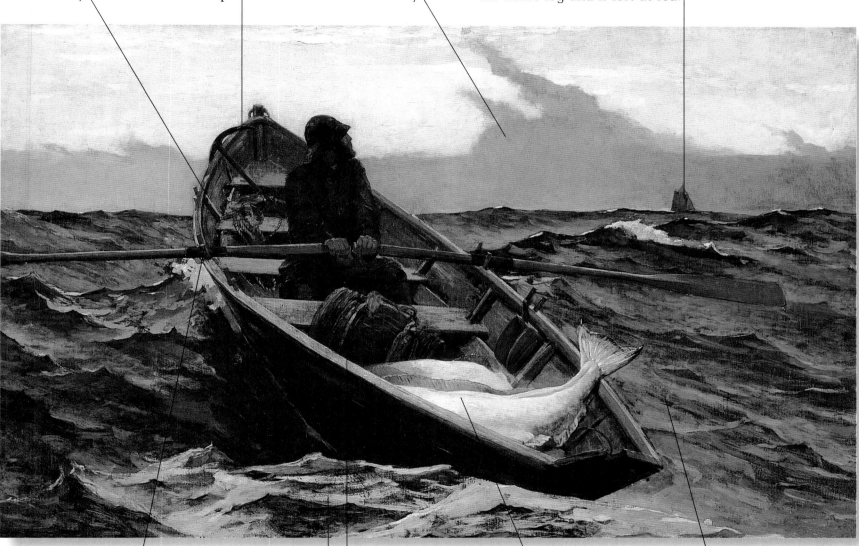

The oars are held in position by wooden pegs fixed to the side of the boat.

With broad sweeping brushstrokes, the artist has given a powerful impression of the stormy sea.

The barrel is used to stop a fishnet from sinking. Attached to the net, it floats on the surface of the water.

The halibut are weighing down the stern of the dory.

The water is deep and dark. The wind is strong and the waves are getting bigger.

Behind the scenes

Homer was fascinated by the power of the sea and painted many dramatic seascapes. This one was painted in 1885. He used oil paint on canvas.

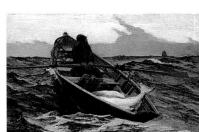

ARTIST Winslow Homer
- An American artist, he was born in 1836 and died in 1910.
- Before he became a painter, Homer worked as a magazine illustrator.
- He lived for much of his life in a house overlooking the Atlantic Ocean.

The Bedroom at Arles

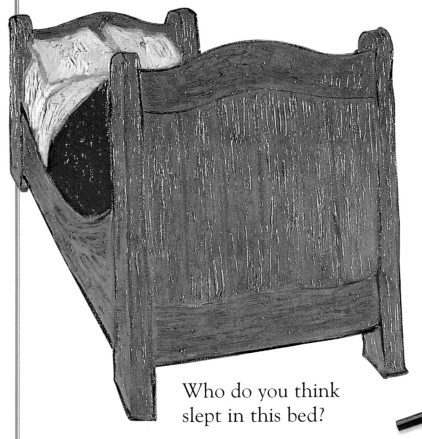

Two years before he died, Vincent van Gogh moved to Arles, a town in the south of France, where he lived in a house called the Yellow House. This is a picture of his own bedroom. The real room was quite gloomy but van Gogh loved to experiment so he used bright colors in the picture. Although he was very poor and often ill, he was passionate about painting and worked very hard. Find out more about him.

Who do you think slept in this bed?

The investigation

[?] Describe the difference between your own bedroom and van Gogh's bedroom.

[?] Describe the colors in the room.

How many chairs are there in the picture?

Find this in the picture. What was it used for?

Who do you think this is?

Can you see anything through the window?

What is this?

One of these things is not in the bedroom. Which one?

The facts

Look closer

Van Gogh used fat paintbrushes and lots of thick oil paint. Sometimes he squeezed the paint onto the canvas straight from the tube like toothpaste.

The pitcher and bowl were used for washing.

The mirror reflects light into the bedroom.

Light shines through the window, but we cannot see the outside world.

A self-portrait of van Gogh

A portrait of the artist's sister

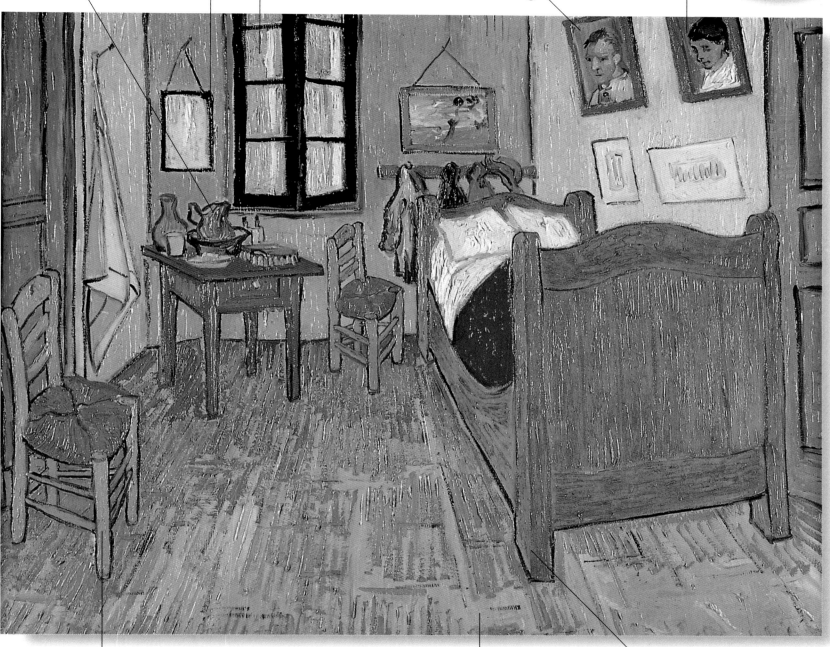

Van Gogh put two chairs in the painting because his friend Gauguin was coming to stay. They had a terrible argument, so the visit was a failure.

The bare floor is made of brick.

Van Gogh slept in this simple wooden bed.

Behind the scenes

There are three different versions of this picture. This one was painted in 1889, the year before van Gogh died. He used oil paint on canvas.

ARTIST Vincent van Gogh

- He was born in Holland in 1853, and died in the south of France in 1890.
- While he was living in Arles he painted more than 200 pictures.
- He is very famous now but he sold only one painting while he was alive.

Tropical Forest with Monkeys

Imagine you are traveling through a tropical forest. You are hot and tired. Suddenly, you come across this scene. You hardly dare to breathe. In the clearing before you there are monkeys, lots of them. Some are quite still, while others are swinging through the branches.

The investigation

Can you see this monkey? What is he doing?

How many exotic flowers can you count in the picture?

Where is this monkey hiding?

? Do you think that the artist painted this scene in a real jungle?

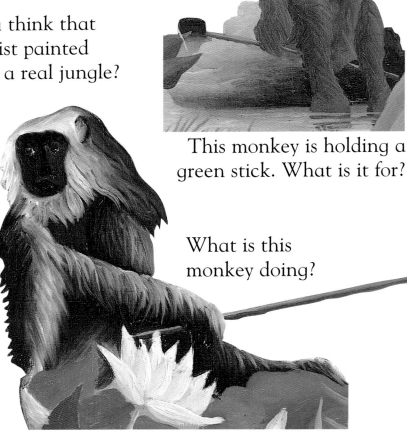

This monkey is holding a green stick. What is it for?

? How many monkeys are there altogether?

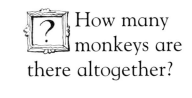

What is this monkey doing?

Look out for danger. Find this face.

The facts

Look closer

There are lots of leaves of different shapes. The artist was inspired by the plants in the botanical gardens in Paris. He never went to a tropical forest.

One of the five monkeys is swinging by his feet.

Blue sky

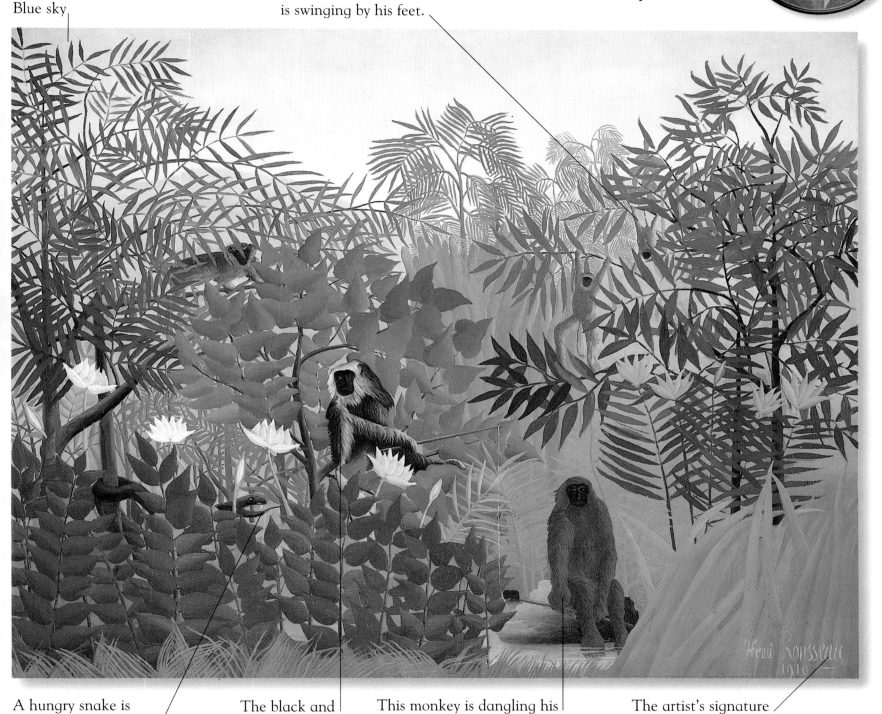

A hungry snake is lurking in the foliage.

The black and white monkey is fishing.

This monkey is dangling his feet in the water. He is holding a fishing rod.

The artist's signature

Behind the scenes

Rousseau painted 25 jungle scenes altogether. He wrote the date of this one, 1910, under his signature. He used oil paint on canvas.

ARTIST Henri Rousseau

- He was born in France in 1844 and died in 1910.
- His nickname was "Le Douanier" (customs officer) because he worked in the Paris Customs Office.
- He took up painting as a hobby.

Self-Portrait with Blue Guitar

When he painted this picture, the artist David Hockney was having fun with shapes, colors, patterns, and different styles of painting. It is a self-portrait, so the man at the table is Hockney himself. He is busy drawing a picture of a blue guitar. He was inspired by a poem he had once read called "The Man with the Blue Guitar."

The investigation

What do you think this pot contains? How many pots are there altogether?

The artist is concentrating. What is he drawing?

Describe the artist and his clothes.

Look at the table. What is strange about its shape?

What is odd about the dark shape under the chair?

Find this.

What sort of flowers are these and what is the vase made of?

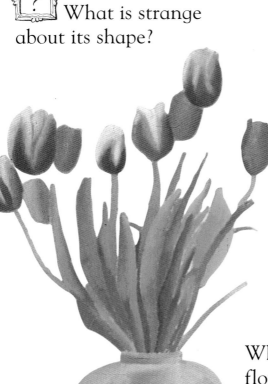

Where do you think the staircase might lead?

The facts

This is a modern sculpture of a head. We can see two sides of the face at once. The artist Picasso developed this style.

Crisscross pattern

The tulips are in a glass vase.

The side of the table farthest away from us is wider than the near side. Usually the farther away something is, the smaller it is.

Look closer
Hockney has dabbed on several different colors of paint to achieve the speckled effect on the table.

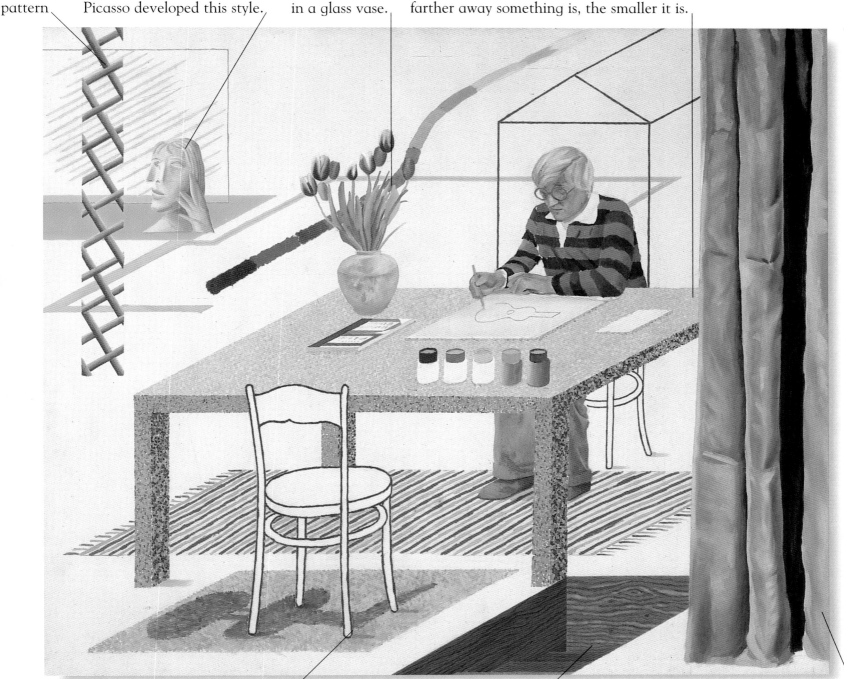

Only the red outline of the chair is shown. The dark patch on the rug underneath looks like its shadow, but it is actually the shadow of a different type of chair.

The wooden staircase does not seem to go anywhere. It is surreal, like something from a dream that does not make sense.

Long ago people used to hang real curtains over their paintings to protect them. At first glance, this curtain looks real. This trick has been used by Dutch painters in the past.

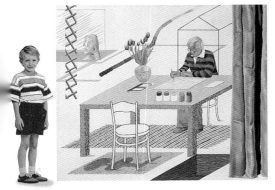

Behind the scenes
Hockney painted this self-portrait in his London studio in 1977. He used oil paint on canvas.

ARTIST David Hockney
- He was born in England, in 1937.
- Hockney likes to explore new ideas. In addition to painting, he has worked in photography, printmaking, and stage design.
- He now lives in California.

Quick Quiz

How much do you remember? Try this quiz and then make up one of your own (with or without pictures) to try on your friends and family.

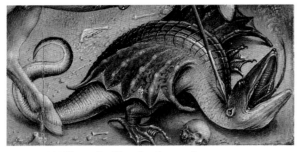

Who killed this dragon?

What is this?

What sort of fish is this?

Who does this dog belong to, and what is its name?

What is this woman doing?

Who is this?

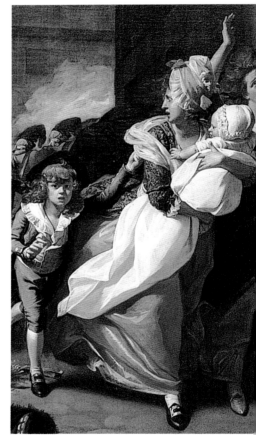

Why are these people frightened?

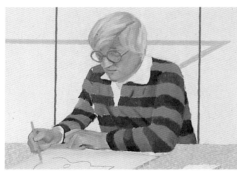

Who is this, and what is he drawing?

Who painted this dog?

Who is this?

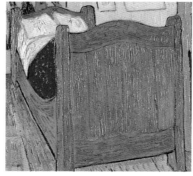

Who slept in this bed?

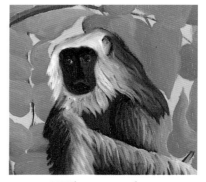

What is this monkey doing?

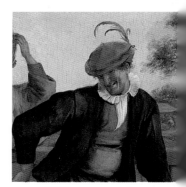

What is this man doing?

30

Further Activities

Look again at the paintings listed here, then try the activities.

Saint George and the Dragon, p. 4

Artists often use symbols to stand for things we cannot see. The dragon stands for the idea of evil. Look for these other symbols in the book: a skull (p.8), bubbles (p.14), roses (p.16), a dove (p.20), and an anchor (p. 23). Draw your own version of each symbol and write down what it stands for.

Primavera (Spring), p. 6

Botticelli painted this picture with egg tempera on a large panel made of wood. Try making your own tempera by mixing powder paint with a little egg yolk for thick paint, or beaten whole egg for thinner paint. Experiment on different surfaces.

The Ambassadors, p. 8

Draw or paint a picture of yourself. Add some of your favorite things, like your pet or a computer, so that everyone can tell what you are interested in.

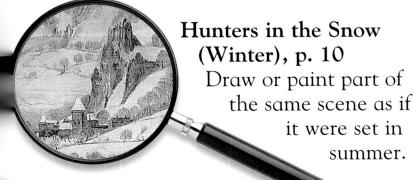

Hunters in the Snow (Winter), p. 10

Draw or paint part of the same scene as if it were set in summer.

The Death of Major Peirson, p. 18

Imagine you are a television news reporter. Find something that looks like a microphone (a wooden spoon would do), and tell the viewers what is happening in the battle. Include sound effects. If you have a tape recorder with a real microphone, you can record yourself and then play it back.

The Fog Warning, p. 22

Paint your own stormy seascape. Try using thick paint and a thick brush for the sea and sky. If you place the horizon high on the page, there will be plenty of room for boats and fish.

The Bedroom at Arles, p. 24

Van Gogh was interested in how we feel when we look at different colors. Draw six boxes. Color one red, one yellow, one blue, one green, and one black. Leave the last one white. Write beside each color what it makes you think of and how it makes you feel.

Tropical Forest with Monkeys, p. 26

Make a collage of a leafy jungle. Cut out leaf shapes from colored paper (any color will do), and stick them onto a large sheet of paper. Add any animals you like.

Self-Portrait with Blue Guitar, p. 28

Draw a picture of yourself that shows what you would like to be when you grow up.

Index

Picture List

p. 4–5 *Saint George and the Dragon*, about 1432/1435
Rogier van der Weyden, born about 1400, died 1464,
Netherlandish, oil on wood,
5 5/8 x 4 1/8 in. (14.3 x 10.5 cm)
National Gallery of Art, Washington, DC
Ailsa Mellon Bruce Fund

p. 6–7 *Primavera (Spring)*, about 1480
Sandro Botticelli, born about 1445, died 1510,
Florentine, tempera on wood,
80 x 123 1/2 in. (203 x 314 cm)
Uffizi Gallery, Florence

p. 8–9 *The Ambassadors*, 1533
Hans Holbein the Younger, born about 1497, died 1543,
German, oil on wood, 81 1/2 x 82 1/2 in. (207 x 209.5 cm)
National Gallery, London

p. 10–11 *Hunters in the Snow (Winter)*, 1565
Pieter Bruegel the Elder, probably born between
1526 and 1530, died 1569,
Netherlandish, oil on wood,
46 x 63 3/4 in. (117 x 162 cm)
Kunsthistorisches Museum, Vienna

p. 12–13 *An Old Woman Cooking Eggs*, 1618
Diego Velázquez, 1599–1660,
Spanish, oil on canvas, 39 1/2 x 47 in. (100.5 x 119.5 cm)
National Gallery Scotland, Edinburgh

p. 14–15 *The Dancing Couple*, 1663
Jan Steen, born about 1626, died 1679,
Dutch, oil on canvas,
40 3/8 x 56 1/8 in. (102.5 x 142.5 cm)
National Gallery of Art, Washington, DC
Widener Collection

p. 16–17 *Portrait of the Marquise de Pompadour*, 1756
François Boucher, 1703–1770,
French, oil on canvas, 79 x 62 in. (201 x 157 cm)
Alte Pinakothek, Munich

p. 18–19 *The Death of Major Peirson, 6 January 1781*, 1783
John Singleton Copley, 1738–1815,
American, oil on canvas, 99 x 144 in. (251.5 x 365.8 cm)
Tate Gallery, London

p. 20–21 *Christ in the Carpenter's Shop*, 1849–1850
John Everett Millais, 1829–1896,
British, oil on canvas, 34 x 55 in. (86.4 x 139.7 cm)
Tate Gallery, London

p. 22–23 *The Fog Warning*, 1885
Winslow Homer, 1836–1910,
American, oil on canvas, 30 x 48 in. (78.2 x 121.8 cm)
Museum of Fine Arts, Boston
Otis Norcross Fund

p. 24–25 *The Bedroom at Arles*, 1889
Vincent van Gogh, 1853–1890,
Dutch, oil on canvas, 22 x 29 in. (55.9 x 73.7 cm)
Musée D'Orsay, Paris

p. 26–27 *Tropical Forest with Monkeys*, 1910
Henri Rousseau, 1844–1910,
French, oil on canvas, 51 x 64 in. (129.5 x 162.6 cm)
National Gallery of Art, Washington, DC
John Hay Whitney Collection

p. 28–29 *Self-Portrait with Blue Guitar*, 1977
David Hockney, born 1937,
British, oil on canvas, 60 x 72 in. (152.4 x 182.9 cm)
Private Collection